PERSPECTIVE DRAWING
FOR BEGINNERS

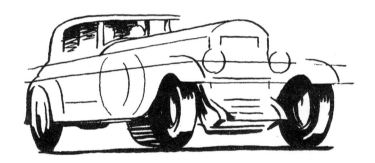

LEN A. DOUST
ILLUSTRATED BY THE AUTHOR

DOVER PUBLICATIONS, INC., MINEOLA, NEW YORK

Bibliographical Note

This Dover edition, first published in 2006, is an unabridged republication of the work originally published by Frederick Warne & Co., Ltd., London and New York, in 1934 under the title *Simple Perspective.*

Library of Congress Cataloging-in-Publication Data

Doust, L. A. (Len A.)
 [Simple perspective]
 Perspective drawing for beginners / Len A. Doust.
 p. cm.
 Originally published: Simple perspective. London ; New York : Frederick Warne & Co., 1934.
 ISBN 0-486-45149-6 (pbk.)
 1. Perspective. 2. Drawing—Technique. I. Title.

NC750.D62 2006
742—dc22

2006040317

Manufactured in the United States of America
Dover Publications, Inc., 31 East 2nd Street, Mineola, N.Y. 11501

Perspectus, past participle of *perspicio* = to see through or clearly : *per* = through, and *specio* = to see.

Perspective—the science of representing appearances.

To see anything in true perspective is a phrase used often in the sphere of philosophy. It embraces the law of relativity; it implies law and order. The true artist works within scientific laws : there is no more excuse for anarchism in art than there is for the bomb-thrower in civil life. Draw within the law of perspective, and your work will at least be intelligible and free from constructional error.

CONTENTS

PERSPECTIVE DRAWING

CHAPTER I

INTRODUCTION

OF all the difficulties that hamper the speedy efficiency of an amateur artist, perspective is the most general and obstinate. The books which I have been privileged to publish on sketching, drawing, and painting have brought to me hundreds of letters, many of appreciation I am happy to say, but mostly prompted by a desire to know more. Let me speak plainly here.

If my earnest and energetic readers would thoroughly master the books even to the extent of many readings, I should receive many less letters of inquiry and, I hope, more of appreciation. In nine cases out of ten I have to repeat certain portions of the book with which my correspondent is so delighted. All teachers find that severity is an essential quality.

Well, I dare not be severe with you who read my books or you will buy no more, perhaps, and then my publishers would not like me. But, believe me, not one word of these little guides has been written carelessly or to make up the number, and all I ask is that you do not pass over a page until completely understood and that you do not neglect the book until you know all it contains. Not that the knowledge is rare, but it is to a great extent essential and, I firmly believe, valuable.

Dozens of go-aheads write to me about perspective. They want simple principles and rules by which they can quickly sketch sea, town, and country. This book

is not a textbook on perspective. There are many complete studies of the subject. Here I have tried to give you short cuts to sound drawing for pictorial purposes and not for architectural designs.

I suppose that everyone knows what is perspective. All who have tried to draw even in the slightest degree know that objects appear to get smaller as they recede, but many have not the slightest idea what rules govern such an illusion and their variation under different circumstances. Hold your finger close to your eye, shutting the other, and see how much is hidden. Hold your pencil up in line with a distant tree and you find they appear equal in thickness. Why is it that the feet of a table's legs are not in a line? If railway lines tend to join one another in the distance, how is one to estimate their slope? Where does one place the horizon? How does one draw two sides of a house in order to make it look true? These are a few of the many questions buzzing in the beginner's brain.

The main difficulty is caused by the unquestionable and all-important fact that you must not draw things as you know they are, but as your eye registers them. You know full well that the railway lines do not draw nearer to one another, for the resulting mishap to the train would wreck it as surely as your picture will be wrecked if you draw the lines parallel.

" Tell me not in mournful numbers . . . that things are not what they seem," wrote Tennyson. Well, mournful news it may be to the beginner in art, but things certainly are not what they seem. The artist is concerned with what they seem. If parallel lines seem to join, you must join them ; if horizontal lines seem tilted, you must tilt them ; just as in the realm of colour, if a brown door appears purple, purple you must paint, and if green grass appears blue or grey, then do not make it green.

I have said enough, I hope, to whet your appetite and

inspire a mite of curiosity for this weird world of contradictions into which we are going to step. Round lines nearly straight, a mile dwindling suddenly to an inch or two, a perfectly sober horizontal line leaping skywards, hands becoming bigger than houses—what a delicious world for Mr. Chesterton to plunge and splash in ! And all under the dreaded, horrid word " perspective." But, as in all fairy tales there are certain laws, passwords, and magic rules, so in perspective there are a few simple principles which, once grasped, will open up a riotous mass of shapes and forms never before seen.

CHAPTER II

LINES IN PERSPECTIVE

THE secret of the railway lines is our first mystery story. But as in most mystery stories, having discovered the facts of the case, that the lines appear to meet and yet in reality do not, we must start from another angle.

The first thing to establish when you intend to draw anything in perspective is your eye level. When I say " anything in perspective," I mean any line that goes away from you. Vertical lines, generally speaking, remain vertical to us. That is to say, two corners of a house or two vertical poles do not appear to meet as do railway lines. See Plate 1, Fig. A. Also two lines running parallel to our eyes as drawn at Fig. B do not appear to join. Only lines going away from us, whatever their angle, seem to meet. See Fig. C.

Let us return to the eye level. This is the level of

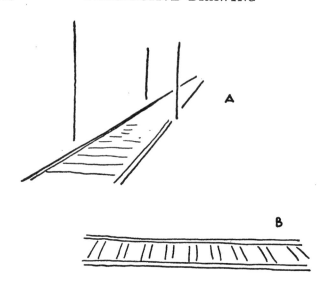

A

B

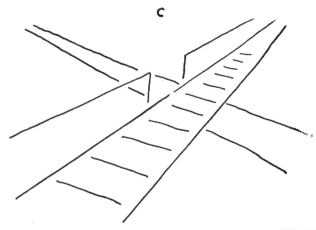

C

PLATE 1

your eye and should be represented on paper by a straight line from side to side. The position of this line on the paper is one for you to decide upon, but when sketching out of doors it will be essential for you to remember that this line is identical with the horizon. On Plate 2 I have briefly sketched three views showing first that the horizon, or where sky and sea meet, is on the eye level, secondly, that mountains and foreground may hide the actual horizon, thirdly, that when the distance is flat it is practically level with the eye line.

The figure in each of these sketches is supposed to be the artist himself. If he stood up his eye level obviously would rise, but so also would the horizon. This is quite obvious when I explain that all lines not vertical or parallel with the artist (see Plate 1, Figs. A and B) slope towards the eye level. For example, our railway lines on Plate 1 will meet at the eye level. But they will also meet at the horizon for the simple reason that they cannot mount into the sky, being earth-bound.

Having thoroughly grasped the two facts that the eye level is the horizon, if you can see it, and that all going-away lines meet at the eye level, you are sufficiently advanced to tackle a very simple object.

I choose a gate as an illustration because it is, in its simple shape, a rectangle. Hence, although I teach you by means of an object, the mathematical outlook is not confused. On Plate 3, Fig. A, I have sketched a five-barred gate, a bush, and my eye level when standing ; below at Fig. B, I repeat the drawing with eye level when I am seated. At Figs. C and D you have a going-away view of the gate with similar eye levels to Figs. A and B. Let us analyse Fig. C.

First, you will notice that the horizontal bars of the gate are all sloping upwards, although you know that they are in reality parallel with the ground and with your eye level. Next you will notice that they meet, when extended, at the spot marked Z. This spot Z is

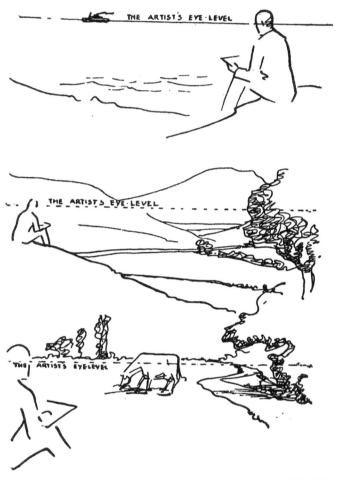

THE ARTIST'S EYE·LEVEL

THE ARTIST'S EYE·LEVEL

THE ARTIST'S EYE·LEVEL

PLATE 2

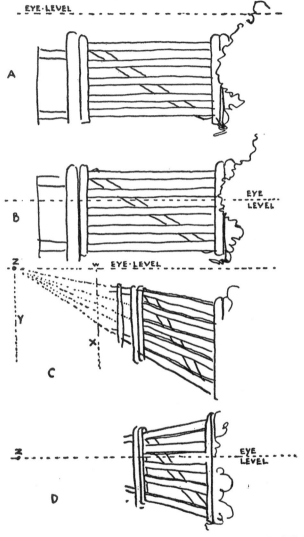

PLATE 3

the key-spot to all perspective drawing. It is the spot where all lines parallel to the top gate-bar meet. For example, the lines of the path edge which runs parallel with the gate also meet at this spot.

The obvious question you are asking is, " How does one find such a spot ? " In strict perspective there are mathematical rules for obtaining this spot. It varies according to your own position. If you are gazing in a parallel line to the gate, that is to say, if your head and shoulders are set at right angles to the gate and, when you look straight ahead, the path of your eyes is as shown at line Y, the spot Z is where this line intersects your eye-level line. But supposing the path of your straight view to be X, then you are opposite to the point W of your eye level. In any such case, where you are not sitting parallel with the horizontal object to be drawn, the method to be used by the landscape artist is more usual and is as follows.

Take your long pencil, or ruler, or any straight line and, holding it before your eyes as nearly level as possible, estimate the angle of slope of the top or bottom bar of the gate. This is made plain on Plate 4, Fig. A. Do not estimate both top and bottom of the gate so ; for not only is it unnecessary, but you increase possible error in drawing. Having obtained the slope of your top line, all you have to do is to extend this line to your eye level, as shown.

The length of the nearer upright is, of course, a matter of taste or composition. You should have roughly sketched in the approximate size of the gate when deciding upon your composition. You can now draw the bottom line of the last gate-bar as shown at Fig. B, from near the base of the post to the point on your eye level at which the top line intersected. The other lines and bars are now sketched in as at Fig. C, all meeting at the same point. Of course, if they vary a little in levelness, you must show this when completing

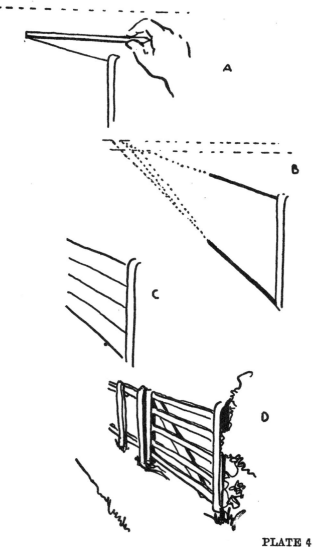

PLATE 4

your sketch. At Fig. D, I show the gate completely
drawn.

You will observe that the line of fence goes to meet
at the same point. The crossbar, of course, is decided
by the width of the gate. The width of the gate is
decided by measurement. Hold your pencil at arm's
length and upright. Push up your thumb until it
marks the length of the nearest upright. Now lower
your pencil, still at arm's length, to a level or horizontal
position, and you can estimate the width of the gate
in perspective in relation to the height of the post.

I illustrate this procedure on Plate 5 because it is
an essential method of measurement for the artist.
Whatever you do, do not let your pencil slope towards
or away from you, and keep it the same distance from
your eye when comparing two objects. In order to
realise thoroughly the errors possible by a careless hold
of the pencil, hold it perfectly level with your eyes
against an object, say the edge of a house or table
which is set at an angle to you, then move it out of
parallel and notice the enormous error caused by the
slight movement of the pencil. Also, when measuring,
hold your pencil upright and measure off with the
thumb the length of any object ; tilt the pencil away
from you and observe how you must drop your thumb,
perhaps half an inch, in order to check the length of the
object.

Now think. You perhaps measure the side of a house
and find it to be six inches on the pencil with arm
outstretched. That house is thirty feet high ; there-
fore, if you make an error by sloping your pencil of half
an inch on your pencil, it will be two and a half feet
in the actual house. You can well imagine the errors
in a drawing where the measurements were compared
with a varyingly sloped pencil. Whenever you use your
pencil for measurement or a comparison of measure-
ments, as we did in finding out the width of the gate,

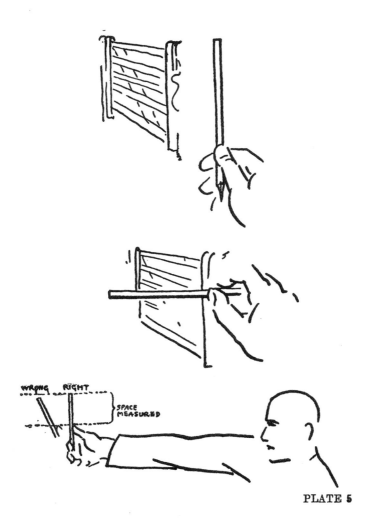

PLATE 5

be sure you hold your pencil parallel with your eyes and, in the case of uprights, strictly vertical.

On Plate 3, Fig. D, I have drawn a gate as from an eye level below the top bar. You will notice that the top line slopes downwards and the bottom line upwards. This is essential as, with the gate in perspective, the horizontal or level lines must meet somewhere on the eye level.

The simple rule is : Every line above the eye level and going away from you, *i.e.*, not parallel with your eyes nor upright, must slope downwards and every such line below the eye level must slope upwards. Also all lines parallel and in perspective meet at the same point on the eye-level line.

The above simple rules are the backbone of perspective drawing and influence every word and illustration in this book. In fact, much of my work is to point out these rules when associated with varying objects, the complexity of which tends to confuse the mind.

CHAPTER III

THE BOX IN PERSPECTIVE

A BOX surrounds most mysteries. Jack-in-the-box, Pandora's box—and even at Christmas we have a phrase to express surprise presents—a Christmas box. So with a box we will continue our study of the wonderful and varied effect of our eyes upon the objects surrounding us.

When you would draw a box you will start with a simple square as shown on Plate 6, Fig. A. This

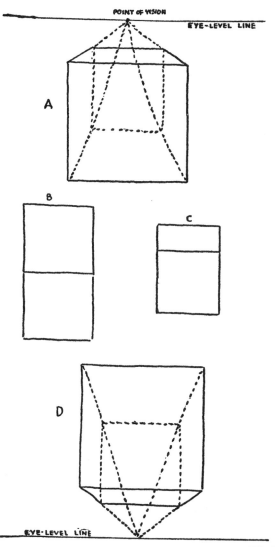

PLATE 6

represents the side facing you. Let us suppose the box
to be perfectly square and to be standing on the ground
directly in front of you. You will notice that the two
sides are invisible. Already you see that magic is at
work—something that is right before you has dis-
appeared. All you can see is the top and front. For
all practical purposes the front view is well drawn as a
perfect square, but when you begin to draw the top
you are in a land of mystery. Actually you know it to
be a square. Yet if you draw it a square as in Fig. B,
or even as a rectangle as at Fig. C, the result is obviously
wrong.

The trick is, of course, to obtain your eye level and
draw the side lines to meet at a spot thereon. It is
very plain that your eye level is the key to the situation
when you realise that, if you are below a box, you see
the side underneath as at Fig. D ; if you are above the
box, you see the top side as at Fig. A.

When the box is directly in front of you the sloping
lines of the top side will be equal and will meet on the
eye-level line at a point directly over the centre of the
box, as drawn at Fig. A.

Now turn to Plate 7, and you see the box drawn from
another angle. The box at Fig. A is obviously to the
left of your point of vision, that is to say, the spot
directly in front of you. This is obvious because you
see one side. Yet the side showing in full view is
parallel with your eyes, therefore the first thing to
draw is a square to represent this side. Actually, the
level side of this square slopes up to meet at the eye
level, but the slope is negligible in a nearly full view.

The next point to notice is that the perpendicular side
is really the same problem as the gate of our previous
chapter. Hence you obtain the angle of the nearest
side line Z. Having obtained the point of vision Y,
you draw lines to meet these from the corners of the
square.

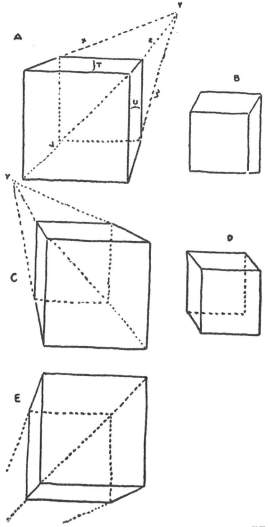

PLATE 7

Another way to work is to set your point of vision or the point directly opposite to you on the eye-level line and, having set your full view square, to draw lines from its corners to this point of vision Y. Anyway, the operation is to obtain point Y opposite to your eyes and draw lines to it from the corners.

You should understand this from my previous plates on the gate so far as the upright side is concerned, but may wonder why the line X must, according to our gate arguments, meet line Z at the eye level. Therefore, having obtained line Z, we can automatically conclude that lines X and W meet it at the eye-level line. Please remember that this is only true when the lines as in a square box (or rectangular box) are parallel. In fact, the bottom of the box at Fig. A is dotted in by the same principle ; line V, being parallel to lines Z, X and W, meets them at Y. The horizontal lines which are parallel with your eye-level line remain parallel.

As to the correct width of spaces T and U, the only method for the landscape artist is an approximate measurement by comparison with another space (say, the height of the front side) by means such as illustrated on Plate 5.

Fig. B shows a square as many beginners draw it. You will notice that the sloping lines do not meet at the eye level but somewhere below the box ; also that the base line of the side view is drawn square. There is no need to describe the wrong effect produced ; it certainly is not a drawing of a square box.

Fig. C shows the same box, but the artist has moved to the other side (or perhaps he moved the box). The principles are the same as in Fig. A ; all that is changed is the point of vision Y.

Fig. D is another example of error. Here we have the lines sloping and the widths accurate, but the lines do not meet at all, being parallel.

It is interesting to observe that, in this drawing of

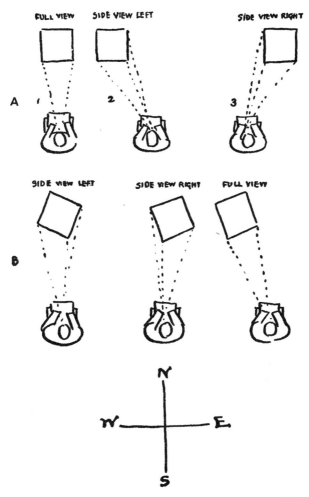

PLATE 8

error, Fig. D, the farther line of the top side, appears longer than the nearer side, although they are exactly equal. Thus I demonstrate the peculiarity that when you draw the actual you appear wrong. A child would admit that Fig. C is more like a square box than is Fig. D.

Fig. E requires little comment. Obviously the artist's eye, and hence his eye level, is below the box. Otherwise the method of drawing is identical with that given for Fig. A.

Heed carefully that in all these drawings I have, for the sake of simplicity, kept one side of the box in practically full view or parallel with your eye level. To put it another way, the reason why you see three sides of the box instead of two, as on Plate 6, is that you have moved to one side of the box, and is not that the box is turned.

On Plate 8, I show a diagram showing the box as we have discussed it in relation to the artist. Underneath I show the other way of seeing three sides, that of twisting the box.

You will observe that the artist in this Plate 8, Fig. A, does not alter his angle of vision, that is to say, his point of vision. Although the box is on one side of him, he does not turn round to face it, but sketches it in relation to the same view. To explain this simply, I have added the four points of the compass. The artist and the box face due north in Fig. A. The dotted lines show the lines of vision from the artist to the corners of the box.

At Fig. B we have a new feature which is apt to be somewhat overwhelming to beginners. You cheerfully grasp all the afore-written rules, then along comes someone and says that it is very seldom an object is drawn with one side at right angles to the artist, that nearly always an object, whether house, table, or box, is set at an angle such as is diagrammed at Fig. B.

The first drawing shows a box directly in front of the artist but showing left side view ; the second, the same box with the same twist showing right side view ; the third shows a box on the left of the artist but turned into full view. Here are peculiar problems. As I have emphasised, only lines that go away at right angles to the eye level, or the artist's full-on position, meet at the point of vision. As none of the sides of the boxes in Fig. B is at such a right angle, we may not assume that they meet at the point of vision, but they must meet at the eye level.

There is this one feature in common with all these boxes on Plate 8 ; it is that parallel lines, going away or in perspective, meet on the eye level.

Let us now turn to Plate 9, where we have a view of a box placed directly before the artist, *i.e.*, centred to his point of vision, and with the foremost edge directly in a line with his point of vision. You will notice the following details in its construction. As the sides showing are equally seen, they are identical in shape and size (compare with Plate 7, where the artist sees more of one side). The going-away lines of each side, being identical in reversed position, meet at points equidistant from the point of vision Y.

All you have to do when sketching such a view is to estimate your desired length for the nearest corner line x, x^1. Now by measurement and comparison obtain the angle of one of the lines a, b, c, or d ; extend line a until it meets your eye-level line, draw the other line b from point x^1 to meet line a at eye-level line. Now repeat this on the other side. Measure and estimate (as shown on Plate 5) the width w, by comparing it with the length x, x^1. Having drawn the side v, v^1 from this measurement, you are able to draw the lines of the top surface without further measurement.

Below I have drawn the progressive stages of this drawing. Fig. A being equisided is extremely simple.

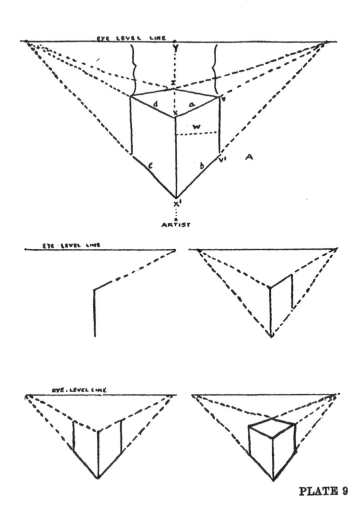

PLATE 9

Notice that the far corner of the top side Z is directly beneath the point of vision Y, or in other words is in line with the centre of the square box. Notice also that the corners at the sides are level as shown by brackets. All these points are useful checks upon the accuracy of your drawing.

Before turning to the following plates, I should like you to take a square or rectangular box and, placing it in this position (Fig. A), with this plate before you, sketch the actual model. You will then see that these rules, so strange and foreign to the artistic outlook, are true to actual appearance.

By this time you are probably getting tired, if not bored, by this tricky subject. . Please admit that a box which stands firmly on the ground is a more admirable object than one, however handsome the carving or polish, which is wobbly. It is more worthy of the true artist to draw a box well than a cottage or mansion badly ; and, as you will soon see, a cottage or mansion can only be drawn well by means of the box.

On Plate 10 I have drawn a few more aerial views of our artist and his box. The first three show (1) a box full view ; (2) a box to one side but twisted into full view ; (3) a box to the other side but still in full view. Fig. B shows a similar movement of the box and an adjustment of its position, that is to say, the artist sees them alike in proportion—they would vary only in size on account of their varying distance.

It is well not to forget the invisible sides of our box, for they may help us to check our drawing. On Plate 11 you see various box drawings with the invisible sides dotted in. You will see that these lines meet at the eye level those visible ones which are parallel. Now one may see very clearly how much smaller appears the far side than the front side. It is wise to sketch such invisible lines when drawing anything in per-

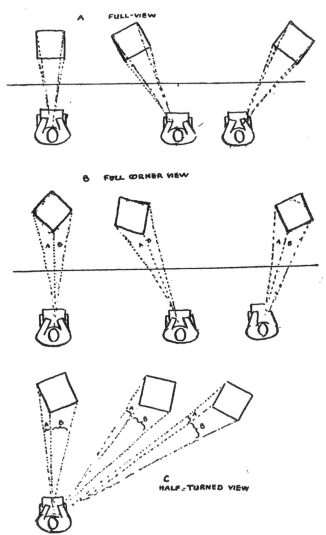

PLATE 10

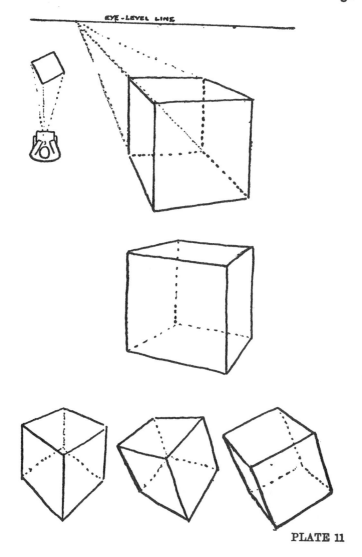

EYE-LEVEL LINE

PLATE 11

spective, for by so doing you will get a clearer idea of your subject.

We will now find a relaxation in a little brick building. We take four square bricks (Plate 12, Fig. A) and place them upon the table and directly in front of us, Fig. B. Now turn them to a full corner view, Fig. C. Now to a half-full view, Fig. D. In these drawings I have dotted in the invisible lines, for they show very clearly that the sloping lines become more nearly vertical as they get lower, and hence the flat or horizontal sides become more nearly square. This is briefly illustrated at Fig. B^1.

At Fig. E we have a pile of four bricks. The top brick is turned as at Fig. D, the second as at Fig. B, the third as at Fig. C, and the bottom as at Fig. D again. You will note that the bottom one does not look square, because I have made it too narrow. I left it in order that you should see how easy is error.

Figs. F and G are perspective views of our pile of four bricks, looking down upon them. They vary only in the angle of the bricks. Heed the parallel lines meeting at eye level, which, of course, is a long way above the bricks.

Plate 13 tells its own simple story and gives one more emphasis to our previous teaching. Five bricks in a row! Then all the going-away parallel lines must meet at the eye level. Observe how flat the lines become as they recede. For example, how flat is Z, Fig. B, when compared with Y. At Fig. C we have taken away one brick. Immediately two of the invisible lines become visible, V and W.

Now let us replace the brick, but outside the line of the others, as shown at Fig. D. You will plainly see that if you have to draw Fig. C or D, or any object of similar construction, you must sketch in the complete row as at Fig. B and afterwards eliminate lines and put in lines necessary to show the gap.

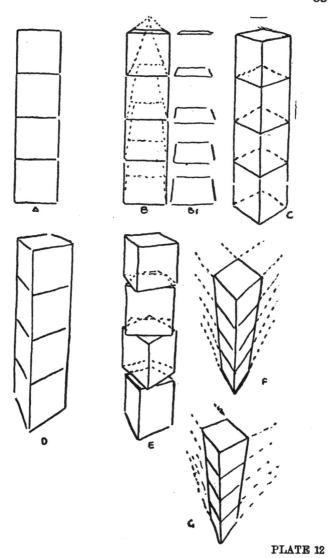

PLATE 12

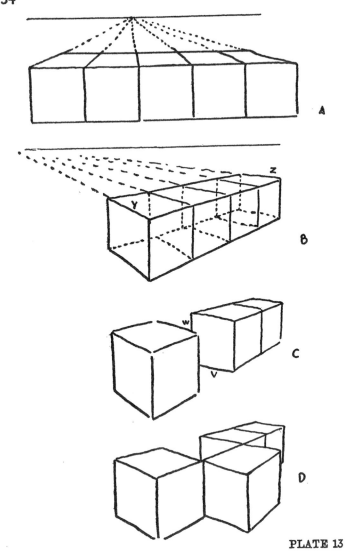

A

B

C

D

PLATE 13

You will recall the drawing of the gate when the eye level was below the top bar. On Plate 14, Fig. C, you see a box in a similar position—the eye level is below the top and above the bottom. Fig. A shows a full front view with lines drawn giving the impression of looking into a lidless box. Fig. B is the same, but half-front view. This aspect of a box is very important, for from it comes the perspective of buildings. Already at Fig. D you may see the budding skyscraper, and at Fig. E the rising row of council houses.

Fig. F shows the altered effect from this middle eye level of an arrangement such as Plate 13, Fig. D. Here, at last, you can faintly see our arrival at building perspective, and turning to Plate 15 we see windows fitted into our boxes, giving quite a house-like effect.

Please pause at this Fig. A of Plate 15 for a few minutes. Do you notice how the level or horizontal lines of the windows follow the slope of the side in which they are set ? Top and bottom, each window-edge slopes to the eye level and there meets the gutter line and ground line to which it is parallel. Never forget this.

At Fig. B you see a sort of gate. At Fig. C this gate is elevated above the artist's eye level ; at Fig. D it is yet higher above the eye level. Please note that the centre line of these gates is not in the centre. There is no need to explain why. Obviously the side farther away is smaller in every way. Hence the lines from centre top to each bottom corner are not equal and vary in angle.

Now fit this seeming gate on to the front of your box. Strengthen the angle lines and you see that they give you the slope of your roof, the only possible variation being in height as suggested at Z. Such variations are to be found by comparative measurement. But, when you have found the front slope of your roof, it is a simple thing to draw the top edge Y in perspective with

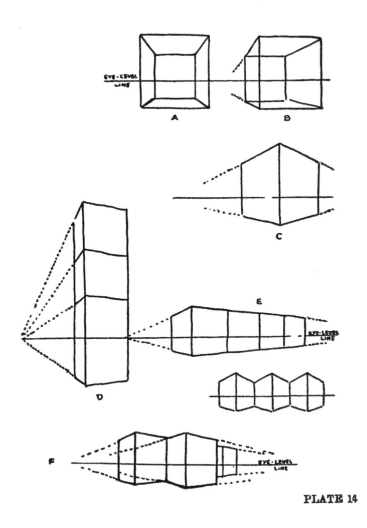

PLATE 14

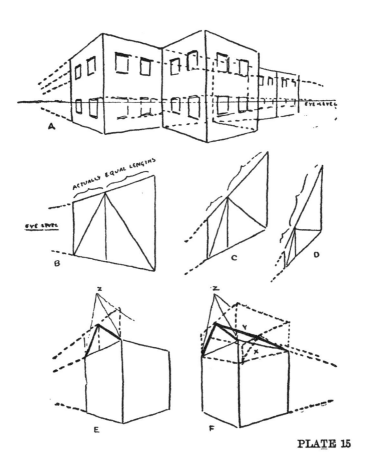

PLATE 15

side gutter line, and to obtain the farther angle of roof by drawing another sort of gate at that end (see X, Fig. F).

CHAPTER IV

THE CIRCLE IN PERSPECTIVE

WE will now vary our studies by taking a circular subject. The perspective of curved lines is but a slight change of outlook from that of straight lines. As a simple example, I have chosen a cup and saucer. Plate 16, Fig. A, shows a simplified plan or full top view of this subject. Fig. B is the same from a normal aspect, Fig. C from a yet lower eye level, and Fig. D with the eye level in a line with the top of the cup.

You will at once observe how the circles of saucer and cup run flatter as the eye level lowers, and finally become straight when the eye level is in a line with the cup rim. Of course, when the eye level is below the circle, the cup rim would curve upwards as at Fig. E.

To draw the perspective of a circle accurately, you should measure the width and then, taking the extreme width to be the cross section of a square, draw lines X, X of Fig. G to meet at the eye level. Then estimate the depth completing the square within which is your perspective circle. This shape is not strictly an oval, for you will notice that the farther or upper section of the perspective square in Fig. G is smaller than the nearer or lower. This results in the farther side of the perspective circle being a little flatter and smaller. However, this slight variation from the perfect oval is

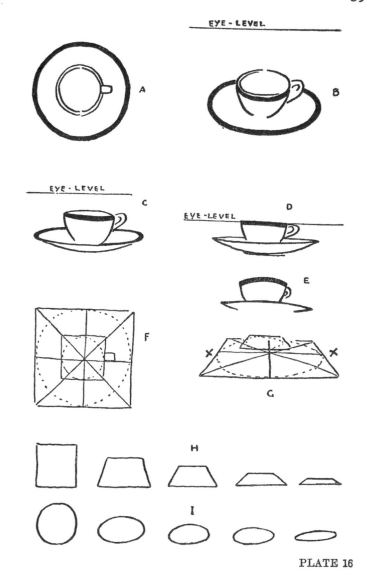

PLATE 16

inconsiderable except in very large shapes or extremely accurate drawings.

At Fig. H and I are shown perspective squares of varying eye level, and their respective ovals or circles in perspective.

The main features of this problem are very simply illustrated on Plate 17. Fig. A was drawn from an eye level in line with the circular base, hence the straight line. Fig. B had an eye level in line with the circular rim, hence it is a straight line. Heed carefully that the rim of Fig. A and the base of Fig. B are curved. Of course, they must be ! And the curve must be bent away from the eye level. To make this quite plain, I have completed with dotted line the ellipses of these circles in perspective. At Fig. C you see the same vase from an eye level slightly above the rim, hence you see into the vase a little. Fig. D has an eye level yet higher ; and at Fig. E the level of the artist's eye was very much higher.

I want you to observe carefully that in Fig. B, where the rim is flat, the base is curved ; hence it is only reasonable to expect that in Fig. C, D and E, where the rim is curved, the base is yet more curved. Obviously, the lower a circle falls from the eye level the more acute becomes the curve. As the eye level is above the vase, the base circle is farther from it than the top, hence the curve is more acute.

This point, an important one, is, I hope, more clearly demonstrated at Fig. F. Here we have five jars standing one upon the other. You will notice that, as the vase and rim are equal size, they fit. Next we have the ellipses or perspective circles of rims, and also, of course, the bases. Finally, we have a four-shelved cupboard into which these vases fit closely. I have filled in the solid black in order that you may see the variation in their width. The inference to be drawn is that the circle nearest the eye level is the flattest, hence

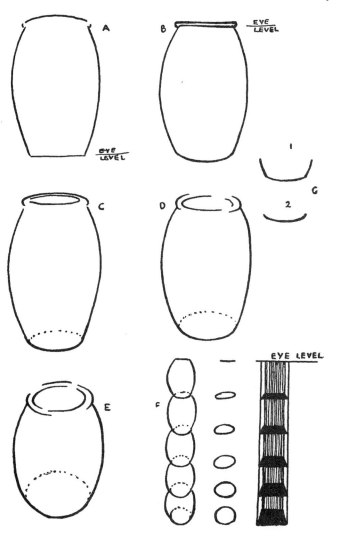

PLATE 17

either the base of a vase must be deeper or more sharply curved than the rim, when the rim is nearer the eye level, or, surely, *vice versa*.

Especially should you learn the lesson in Fig. G. Never draw the base of a vase, cup, etc., as shown at 1, *i.e.*, with sharp edges. Always let the ellipse of the base merge into the side line, as very clearly shown at Fig. D.

It may surprise you to have to consider a saucer as a form of vase, but that is how I wish you to look at Plate 18, Figs. A and B. The reason is that a saucer has a rim and a base. Fig. B shows a saucer as it would look if flattened ; Fig. A shows a saucer as it is. Notice that the base drops out of centre because it rests on a lower plane. If one had a square saucer the effect would be as shown beneath Fig. A. You will appreciate how the dropping of the base gives a saucer-like shape, whereas the drawing Fig. B has a tray-like effect. Observe that the centre ellipse of Fig. B and the centre square of B are slightly above the actual centre of outside shape. This, as has already been explained, is due to the perspective centre of a flat square being above the actual centre. Test this by drawing diagonal lines and noting where they cross (see Fig. B). Really, the principle is but that of the shelves on Plate 17, Fig. F : the base of the saucer is farther away from the eye level and therefore is wider in proportion and set lower.

Now we will return to a simple curve in constructional perspective. An arch such as drawn on Plate 18, Fig. C, is very easy. Note the perspective slope of base lines. When turned slightly it presents the appearance of Fig. D. Note the dotted line showing the hidden edge. Note the narrowing width.

A pointed arch repeats the problem of the house roof. Draw carefully the dotted lines of Fig. E, and you will find no difficulty in placing the pointed arch.

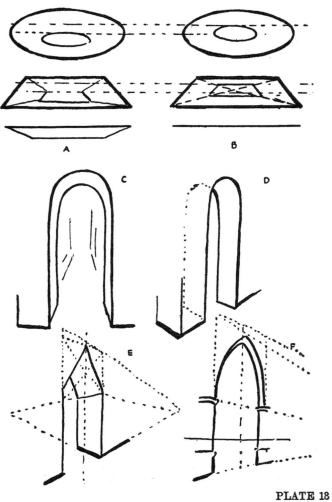

PLATE 18

Once again I direct your attention to the centre or apex line. This is not exactly between the two sides (see Plate 15, Figs. B, C and D). A Gothic arch as drawn at Plate 18, Fig. F, is obtained by similar means to Fig. E. The top dotted line of these drawings slopes to the eye-level line to meet other parallel lines such as the bases of pillars.

CHAPTER V

PERSPECTIVE APPLIED

OUR next Plate takes us into the country. Plate 19, Fig. A, is a diagram very much resembling a wide railway track, the level lines answering for sleepers. It requires no emphasis, at this stage, for you to know that these spaces are equal-sized rectangles in perspective. If you apply the principles of this diagram to the sketch at Fig. B you will appreciate the value of them when sketching landscape.

The first and foremost law to impose upon a landscape is that of perspective. Bear in mind the rapid and proportional narrowing caused by distance. Turning back to Fig. A, I suppose each space to be an equal-sized field on a slightly rising surface. Notice the effect of perspective and apply it to your work.

Fig. B shows an effect of zig-zag lines caused by the sloping of ridges and field edges ; such is a common occurrence in gently undulating land.

Fig. C diagrams this form of perspective. The hedges a and b on Fig. B are approximately in a direct line from the artist, i.e., parallel with the straight line

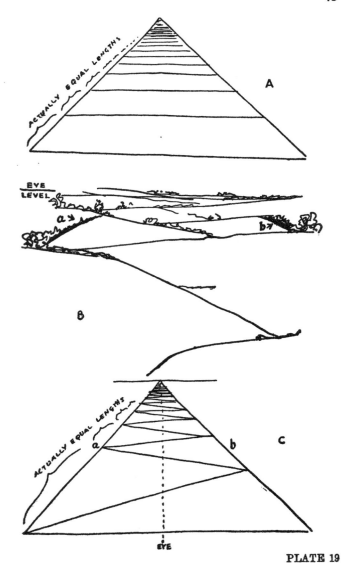

PLATE 19

of vision from artist to horizon ; hence they are similar in slope to the lines a and b of Fig. C.

When you would draw clouds perspective is still with you. But it is inverted, the outlook of the artist being that of the bottom of a box instead of the top : one appears to be seeing the underside of shapes, as indeed is the literal fact. On Plate 20, Fig. A, I have drawn a simple outline of a cloudy sky. Fig. B is a more simplified arrangement showing clearly, I trust, the perspective—the narrowing and diminishing size of clouds due to distance.

At Fig. C is a simplified drawing of the sea, once again demonstrating the vital feature of perspective in the narrowing of space between the wave lines. I can but show you the principle, for sky and sea and landscape change continually, have their own difficulties and modifications. Nevertheless, if you thoroughly grasp and retain the simple principles illustrated here, you will succeed where otherwise, however pleasant your colour and composition and subject, the result would be an inevitable failure.

The illustrations on Plate 21 should present little difficulty for you. I will direct your special attention to the slope of the base supports to the bridge in Fig. A ; they meet at the eye level, which is on a level with the head of the man on the bridge. This is because the artist was seated at exactly that height. Notice also that the farther curved edge of the arch (completed with dotted line) is higher throughout as, obviously, it is nearer the eye level. It is always safest to complete such half-seen curves in order that the part you do see may be accurate. In nothing does the eye deceive easier than when estimating a partially hidden curve.

Fig. B shows a simple method for obtaining the correct width of the varying arches. Estimate your desired width for the first arch a ; draw the vertical line b, bisect it and draw lines from corners c and d through

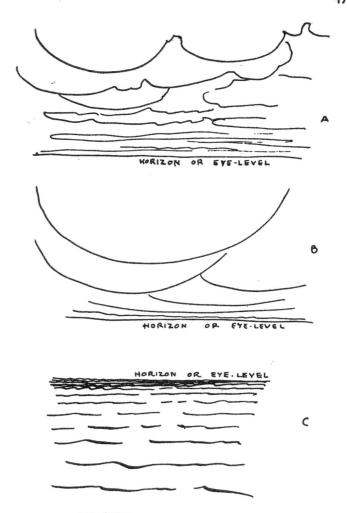

HORIZON OR EYE-LEVEL

A

HORIZON OR EYE-LEVEL

B

HORIZON OR EYE-LEVEL

C

PLATE 20

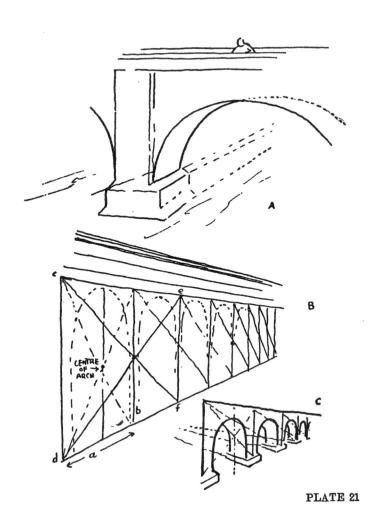

PLATE 21

it. Where these two lines meet your already sketched perspective parallels of the bridge at e and f, you can draw your next vertical. Continue this procedure and you can extend your bridge as far as you please with each space in accurate perspective.

Fig. C shows this principle carried out in an actual bridge. Without such a geometrical rule to guide you, you will undoubtedly fail to make your arches reduce sufficiently as the distance increases.

Plate 22 shows a common object which presents difficulties to the beginner in perspective. A chair, one might think, is easy to draw. But I can assure you that it is not at all simple, owing to the subtle curves so often found in the back.

If you consider a chair as a box with a back, you will be making headway. Narrow the box at the back, and you will be nearer the truth. Copy several times the three little drawings at Fig. A, and you will learn the principles of chair construction. Do not forget that the lines in perspective meet at the eye level, as illustrated sketchily at Figs. B and C. The drawings on this Plate are facsimiles of quick chair studies, showing how wise it is to sketch the direction of all lines in order to be sure they are meeting at the eye level. Of course, one cannot always continue these right up to the eye level, but, with pencil measurement to help you, you can manage to obtain a degree of accuracy in the gradation due to perspective. Observe carefully the lines that are really parallel and should, therefore, meet at the eye level.

On Plate 23 we return to the box principle. Fig. A shows in diagram the full front view of the interior of a box. Fig. B shows a slightly one-sided view. Notice where the point of vision or the spot directly opposite the artist is marked PV. Figs. C and D show these boxes with a portion cut away. Such is the usual view one uses when drawing interiors. Below at Figs. E and

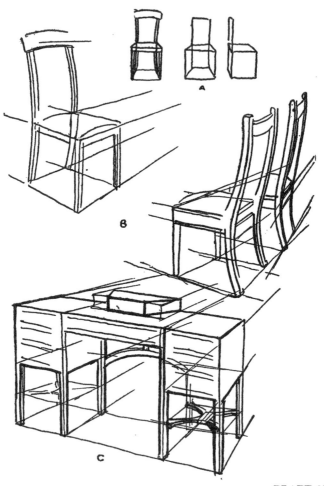

A

B

C

PLATE 22

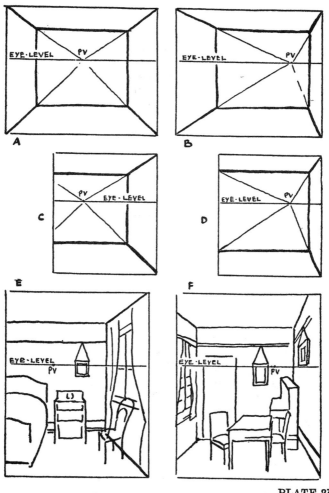

PLATE 23

F, I have briefly sketched furniture, etc., into two box shapes of equal proportion to Fig. C and D. Heed all the sloping lines and their meeting spot—the point of vision.

These sketches appear very simple and indeed are so, chiefly because the wall facing the artist is dead level, that is to say, parallel to his eye level. If, as on Plate 24, Fig. A, there is no line directly parallel but all are more or less in perspective, then an accurate drawing is more difficult and will entail either a lot of geometrical perspective, or else careful estimation of slopes by means of your pencil as explained earlier in this book.

When drawing interiors, obtain first a rough sketch of what you wish to include. Next get the perspective of the walls right ; then the largest pieces of furniture and decoration ; and finally the detail. If you commence in one corner and work down, trying to get everything right as you go, then you are rushing to disaster. Whenever and whatever you draw, work from the whole to the part and the part to the section —work from the main to the lesser, from the framework to the detail.

The sketch of a motor-car on Plate 24 is a good example of the above statement. With such a sketch it would be easy for anyone to produce a finished drawing from the model. The only lines of perspective are those showing on each side of the front wheel. You will notice that the eye level is practically on the ground. An unusual view, you may say ; yes, but a very useful and cunning trick often used in advertisement drawing. Always is the dignity and apparent size of an object increased by the use of a low eye level.

The many chairs at various angles drawn on Plate 24, Fig. A, are a simple illustration of a complex subject. Without any aid but your pencil for measurement, and

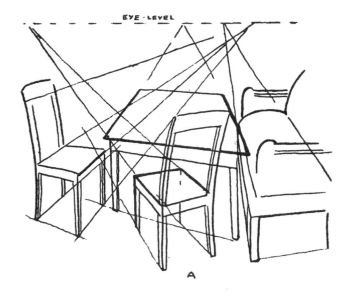

A

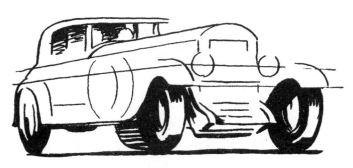

PLATE 24

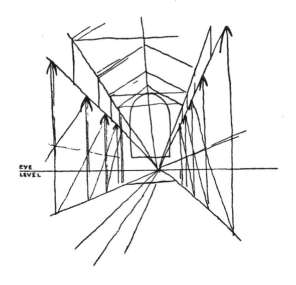

EYE
LEVEL

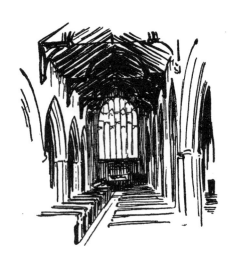

PLATE 25

your eye level drawn on your paper, you should manage
such a subject with ease if not without care. This is a
facsimile of my original preparatory sketch.

The view of a church nave on Plate 25 shows how
simple is the accurate construction of such a drawing
by means of our pencil for level and upright measure-
ments and the accurate drawing of parallel going-away
lines. It would help you to copy this sketch, quickly,
a few times ; and then to try an actual subject similar
in form.

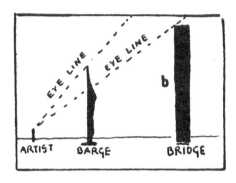

I include the sketch of the barge before Tower Bridge
Plate 26, Fig. A, in order that you may appreciate the
effect of a low eye level. The barge's sail towers over
the bridge for the simple reason illustrated in the small
sketch. Notice the lines of vision to the tops of two
lines, and how in spite of b being actually taller it will,
as seen by the artist, appear smaller.

The peculiarity of Fig. B is the curving bridge which
causes the spaces between the girders to be much more
even than if the bridge were straight (see small drawing).

Plate 27 is devoted to perspective of an aerial view.
Observe the enormous difference between Fig. A and
Fig. B. In the first the eye level is very high ; in the
other, it is but a little above the bridge balustrade. I

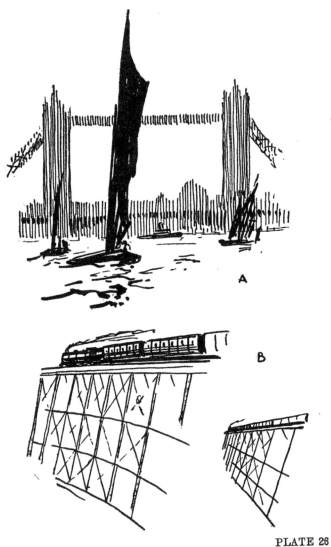

A

B

PLATE 26

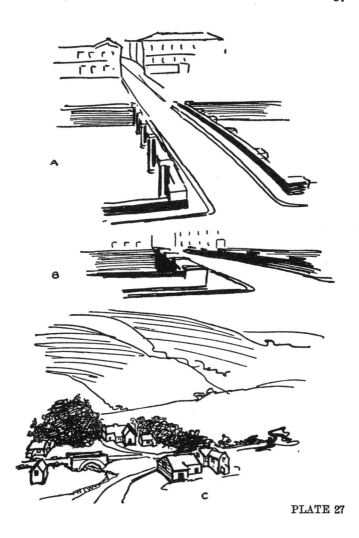

PLATE 27

leave you to observe and remember the variations caused by this change of eye level.

Fig. C shows another lofty eye-level view. Observe the slopes of the house sides. It would help you to realise the effect of such a view, if you were to draw these little houses on a piece of plain paper with no surroundings. Immediately you will feel the effect of height.

The final six plates of this book are, I trust, self-explanatory. But if you cheerfully glance at them and close the book with a remark about the simplicity of perspective or the exceeding difficulty of perspective, they will have explained nothing. That you may grasp their tuition easily and quickly I advise the following practice: on a piece of paper draw freely, but as accurately as possible and twice the size of the sketches, Plates 28, 30 and 32, and upon these copy Plates 29, 31 and 33.

I have now briefly shown the way to approximate accuracy in perspective. If there is any point which you wish to learn and which is not in this book, buy —secondhand easily—a book on geometrical or architectural perspective. As I forewrote, this book is an attempt to make perspective drawing possible to the artist-beginner. This world of things not as they are is like many fairylands, a little monotonous, but, applied to the " actual," makes for beauty and a truth more beautiful than literal.

Perhaps I may be forgiven if I add one more definition of art to the many. Art is taking things as they are and setting them in the sphere of what they seem.

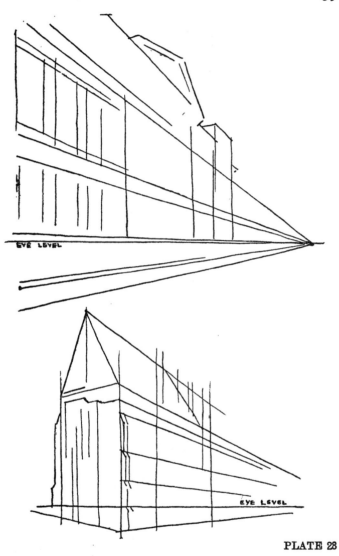

EVE LEVEL

EYE LEVEL

PLATE 28

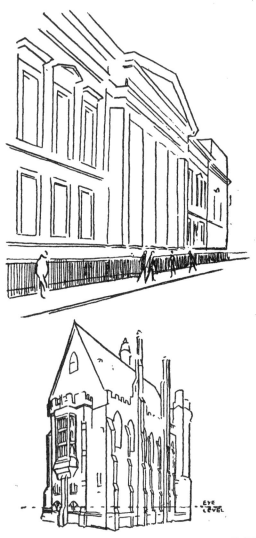

PLATE 29

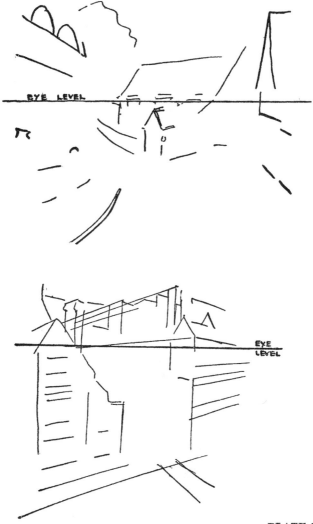

EYE LEVEL

EYE LEVEL

PLATE 30

PLATE 31

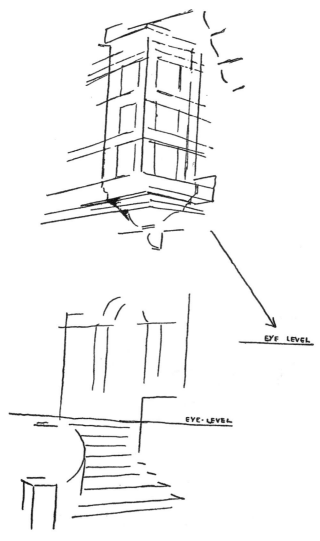

EYE LEVEL

EYE- LEVEL

PLATE 32

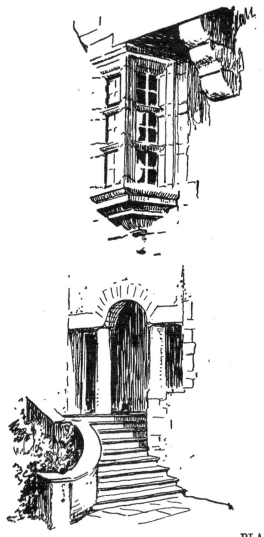

PLATE 33